ONE SHOE BLUES

 THE MOVIE

THE STORYBOOK

PLUS SPECIAL FEATURES
- THE MAKING OF "ONE SHOE BLUES"
- SOCK PUPPET SCREEN TESTS

MOMSOCK

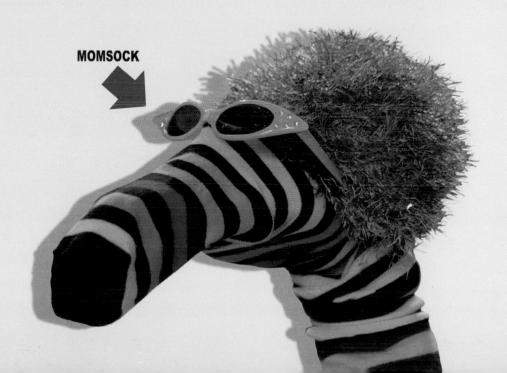

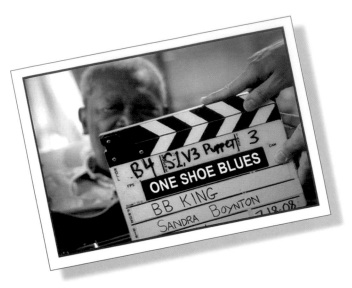

THIS BOOK IS DEDICATED TO PEOPLE WHO LOSE STUFF

The song "One Shoe Blues" was first released on Boynton's **BLUE MOO:** *17 Jukebox Hits from Way Back Never*
Words and music by Sandra Boynton • Vocals and lead guitar by B.B. King • All other instruments performed by Michael Ford
Arranged, produced, and mixed by Sandra Boynton and Michael Ford

ISBN 978-0-7611-5138-8
WORKMAN PUBLISHING COMPANY, INC., 225 Varick Street, New York, NY 10014-4381
Printed in China
First printing September 2009
10 9 8 7 6 5 4 3 2 1

CONTENTS

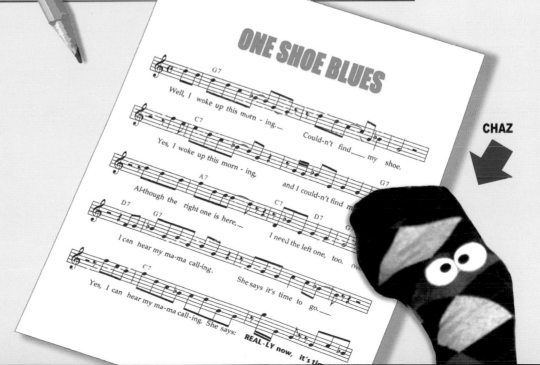

CHAZ

★ STORYBOOK ★ SO

ONE SHO

WRITTEN, DESIGNED & DIRECTED BY

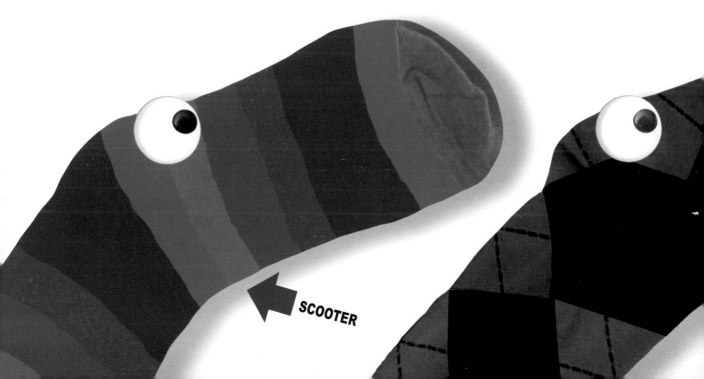

SCOOTER

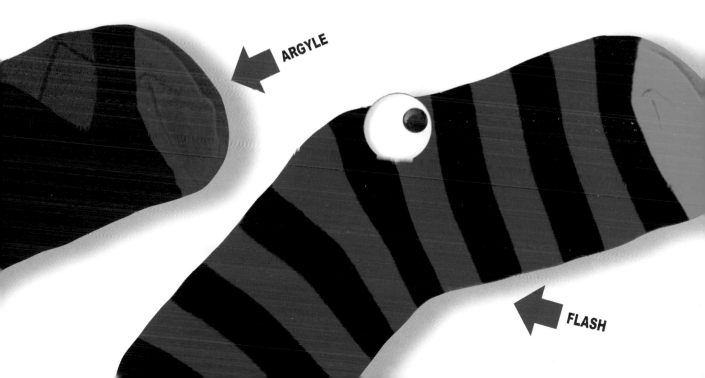

G ★ MOVIE SHORT ★

E BLUES

Starring B.B. KING

★ SANDRA BOYNTON

← ARGYLE

← FLASH

THE STORY OF "ONE SHOE BLUES"

We might be in Mississippi. Or maybe not.

Here is somebody's house, at the very end of some long and lazy country road, on a breezy day in late summer. It's morning.

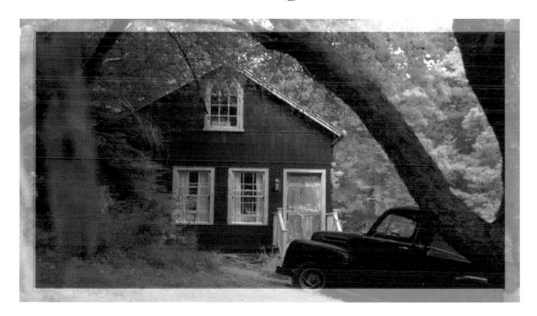

Look.
No one is sleeping
in the little bed
of the little house.
I think maybe
whoever lives here
is already awake
and up for the day.

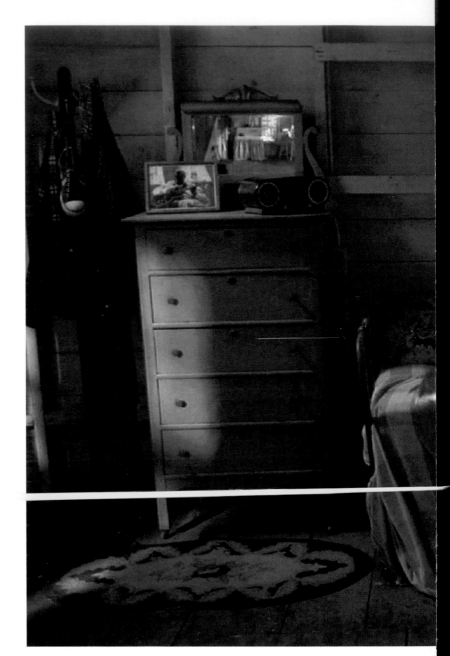

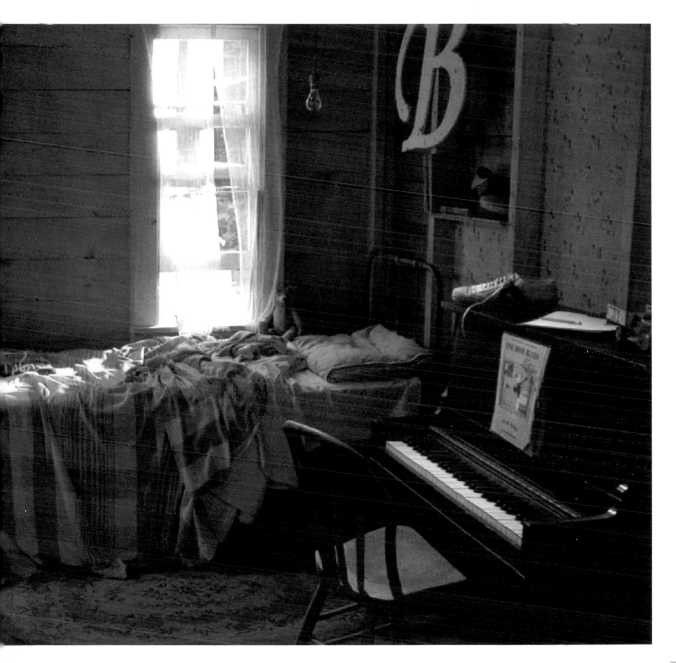

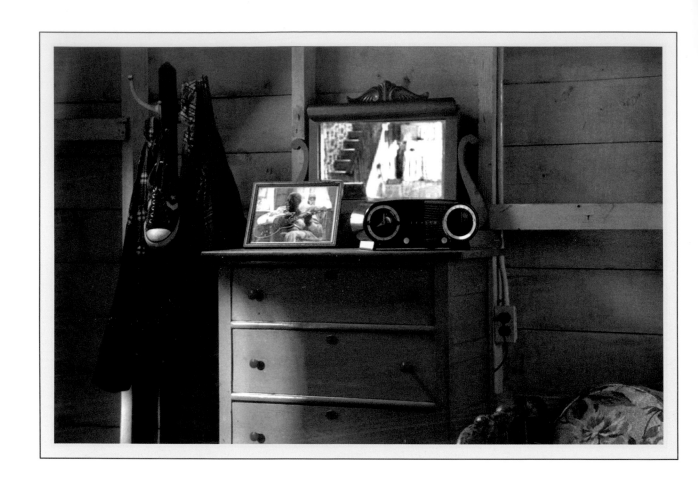

On the dresser, near the bed, there's an old clock radio.
At exactly 8 o'clock, it clicks on.

There follows the curious hum and buzz
that an old radio makes when it's warming up.
And now we hear a friendly voice saying:

*"And you know what? Blue skies today. Temperatures will be
in the high 70s. Right now, how about a little…**B.B.KING!**"*

An old familiar song begins to play.

All of a sudden, the top drawer opens and out springs Dexter, a bold striped sock. Dexter adores this song, and so he begins to sing along:

"**W**ell, I woke up this morning.
Couldn't find my shoe."

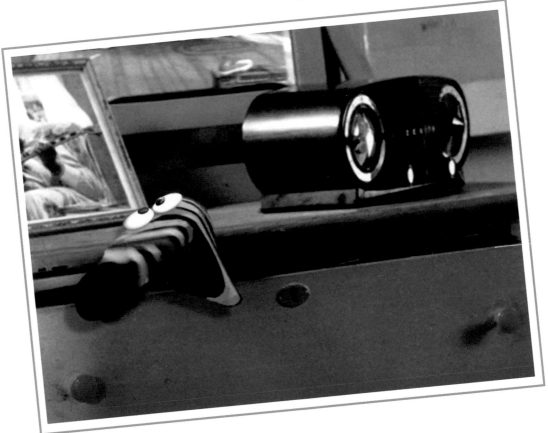

And now here comes Riley, another bold striped sock,
and it's his turn to sing:

**"Yes, I woke up this morning, and I
couldn't find my shoe."**

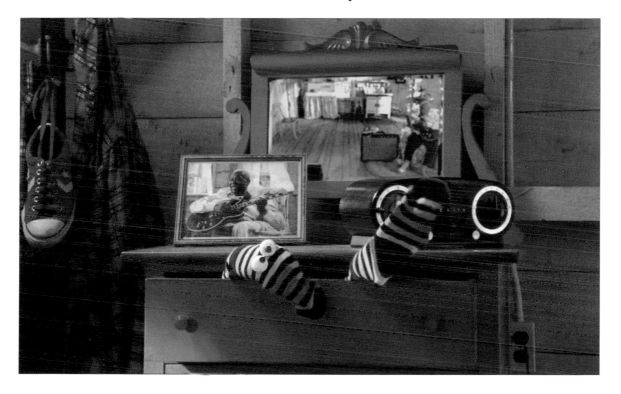

But wait. There's a live guitar playing along.
It's not coming from the radio.
Where's that sound coming from?

Oh, look! There in the mirror!
Somebody else is in the room.

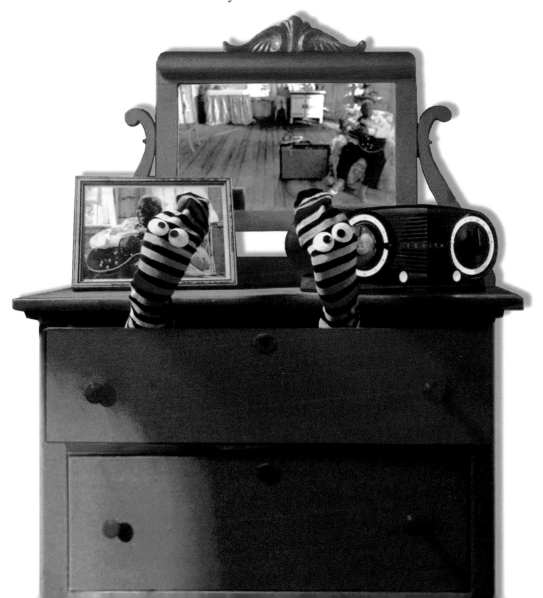

Dexter and Riley turn and stare.
Can it be?

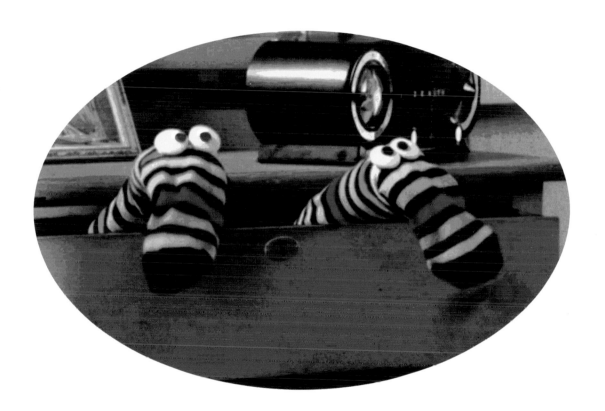

Whoa my my, oh yes indeed, it really is, it's…

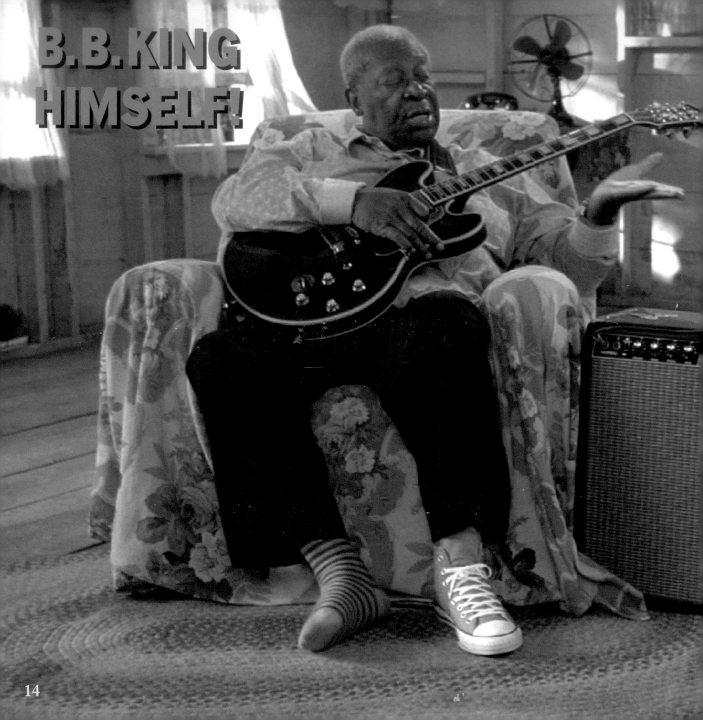

B.B.KING
HIMSELF!

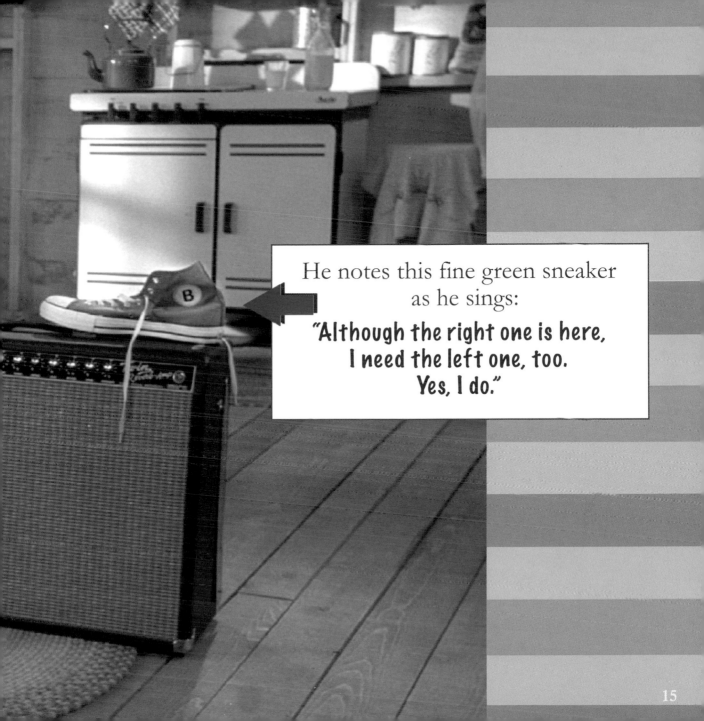

Dexter and Riley are watching and waiting.
They know exactly where B.B.'s other green sneaker is.
Did you happen to notice it, too?

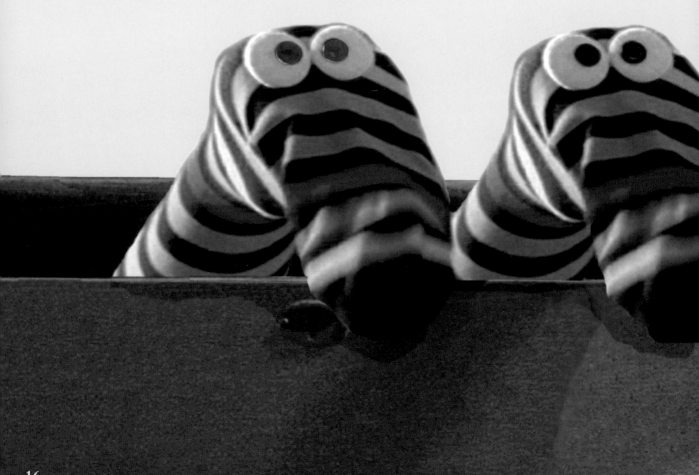

But B.B. just goes right on singing.
Let's listen.

"I can hear my mama calling.
She says it's time to go.
Yes, I can hear my mama calling.
She says:
'REALLY now. It's time to go.'
I say:
'Mama, I can't find one of my shoes!'
And she says:
'OHHHHHH, no. Not again!'"

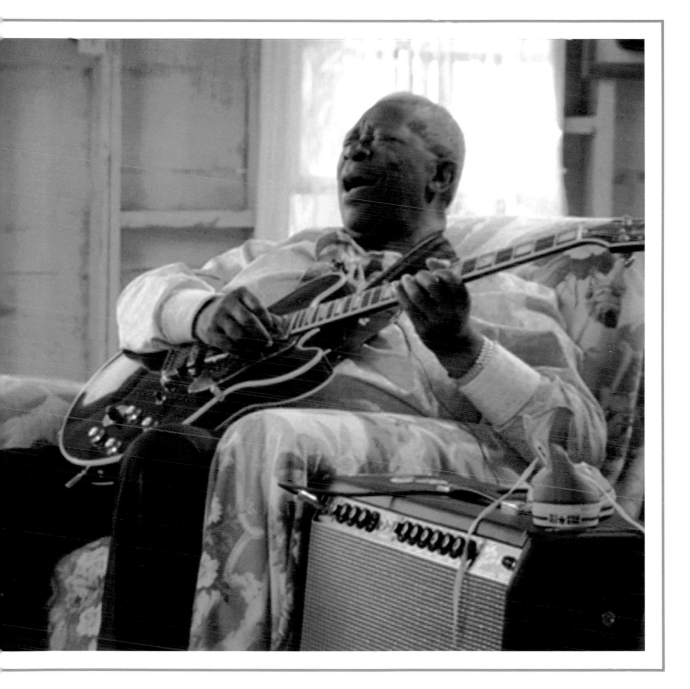

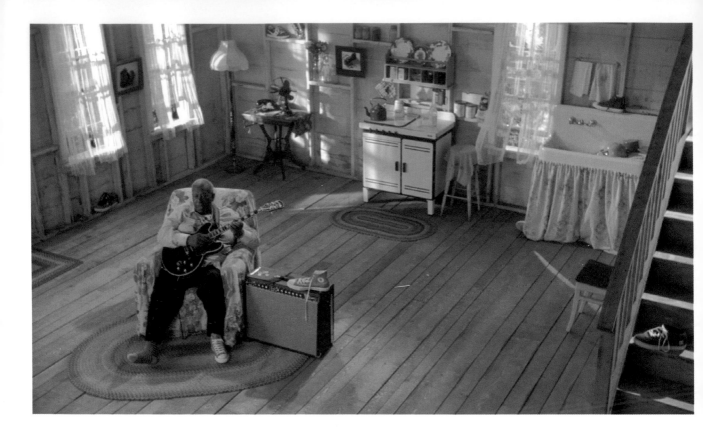

"**I** got the One Shoe Blues.
It seems they're never gonna stop.
Yes, those One Shoe Blues.
Oh! They might not ever, ever stop.

Tippy wants to know how many shoes you see.

Mama says, *'Just come on along now…'* "

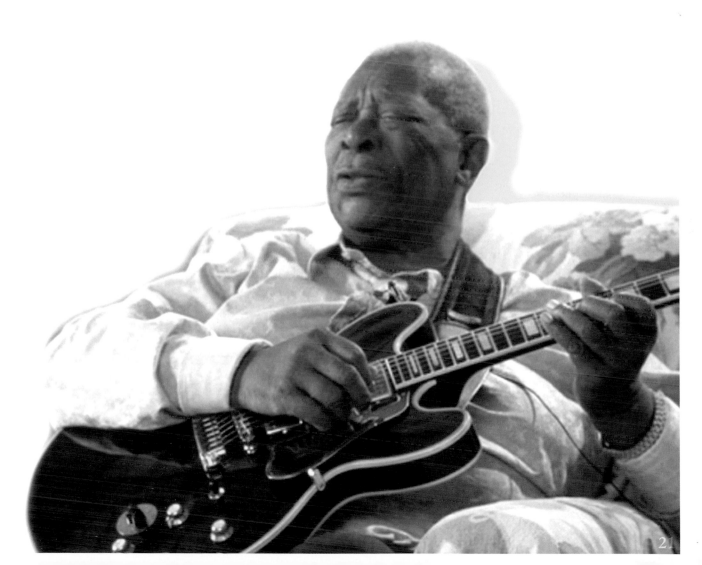

"One Shoe!" says Scooter from the laundry basket.
"Do you expect me to hop?" adds Flash.

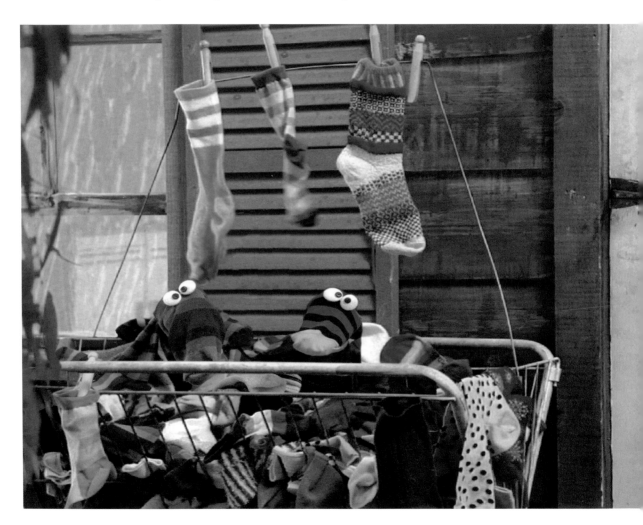

But B.B. doesn't hear them.
He's busy with someone else, namely: Momsock.

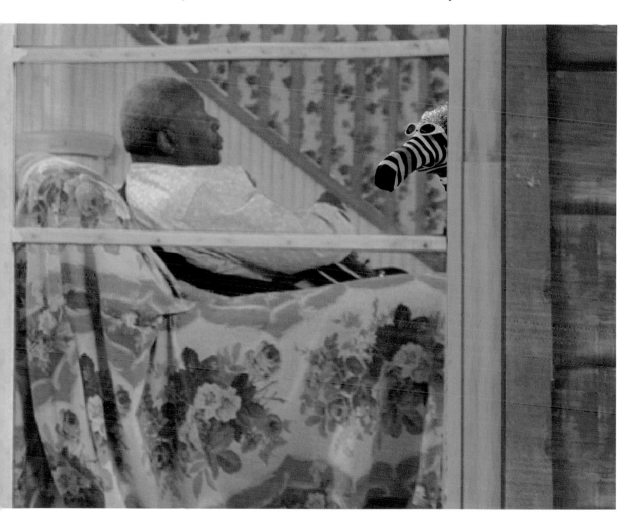

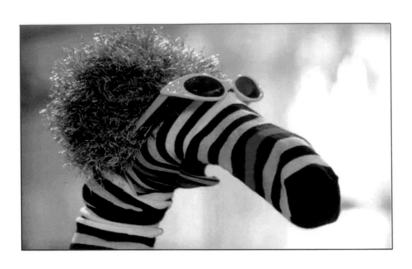

*"Did you look in the closet
and under the bed?"*

"Yes, I did."

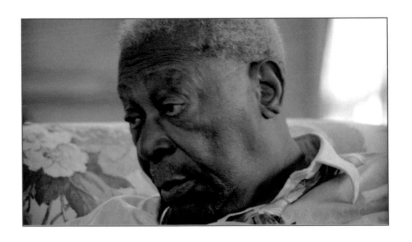

"Did you look CAREFULLY in the closet and under the bed?"

"Yes. Yes, I did."

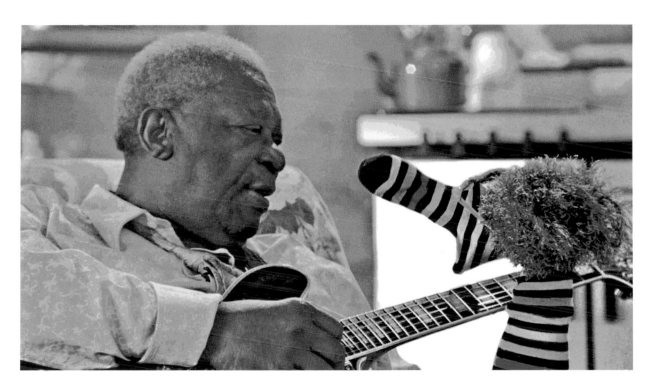

"Try and think where you left it."

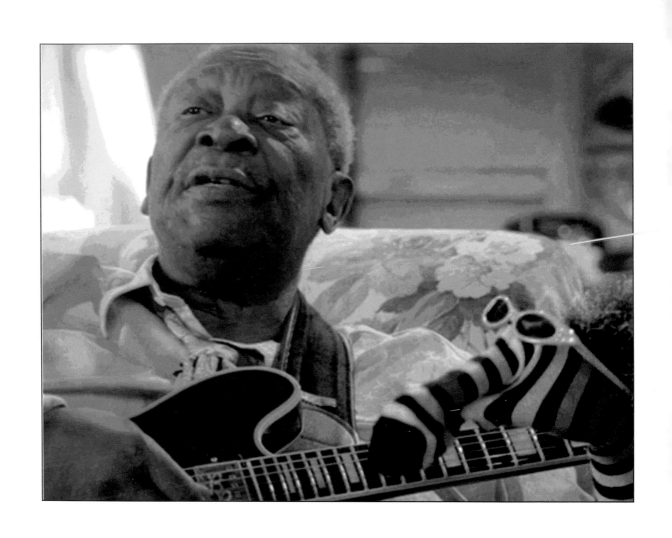

"That's what my mama said."

" **L**ast night I left it right here
next to my other shoe.

I know I put it right here
next to my other shoe."

"I think
somebody
took it—

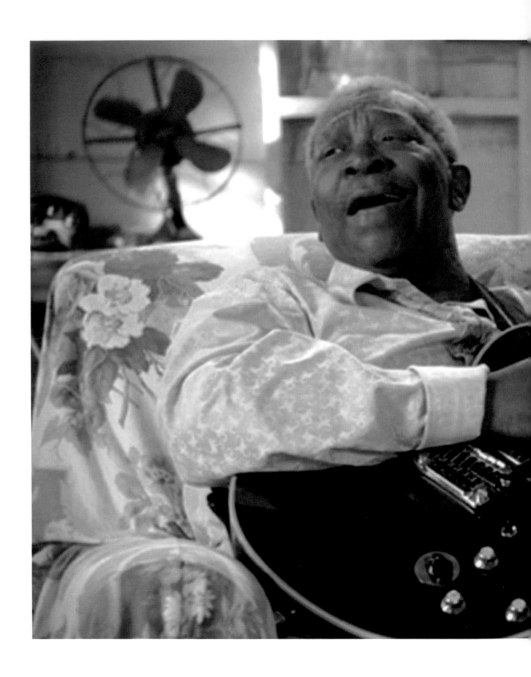

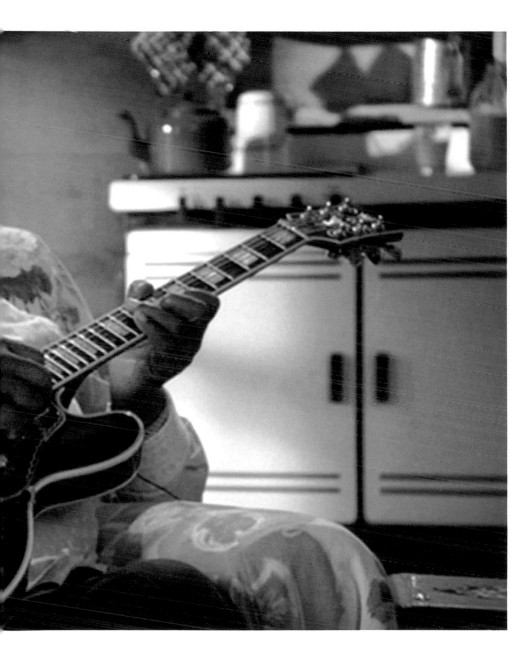

but I
don't know
who.
No, I don't."

As B.B. continues the song,
three curious socks appear in the window.

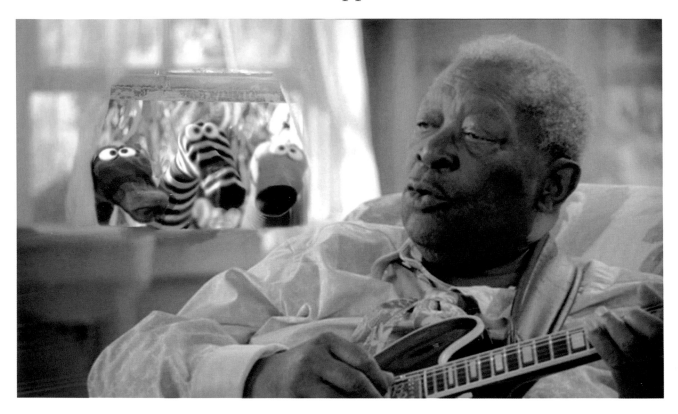

"Got the One Shoe..."

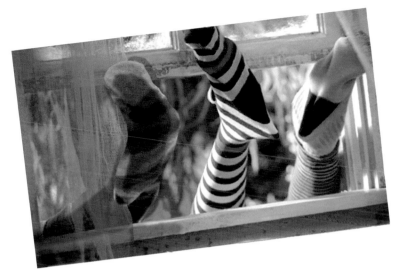

"ONE SHOE BLUES!"

B.B. looks around, startled, but the socks
have already ducked out of sight.

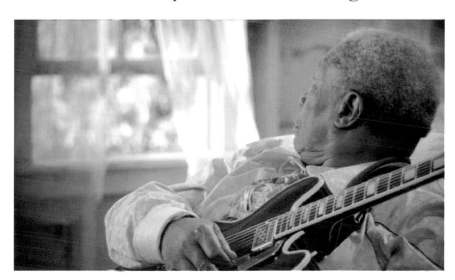

Huh!

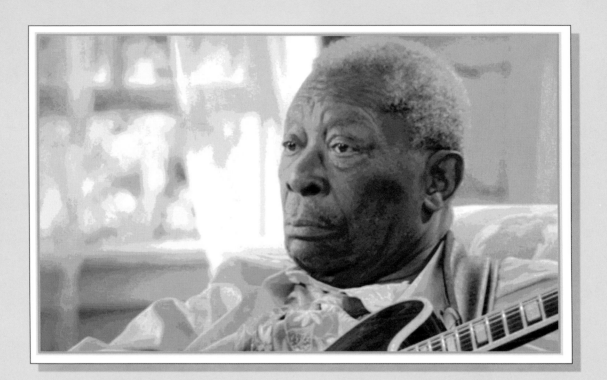

"That's why I'm singing this song.
I got the ONE Shoe Blues,
and so I'm singing this sad song."

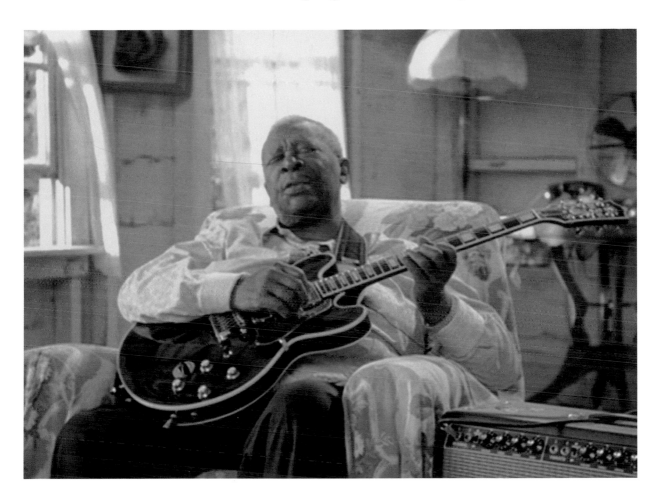

"You know it's been at least **TWENTY MINUTES**
that I've been looking in every **POSSIBLE** place for th..."

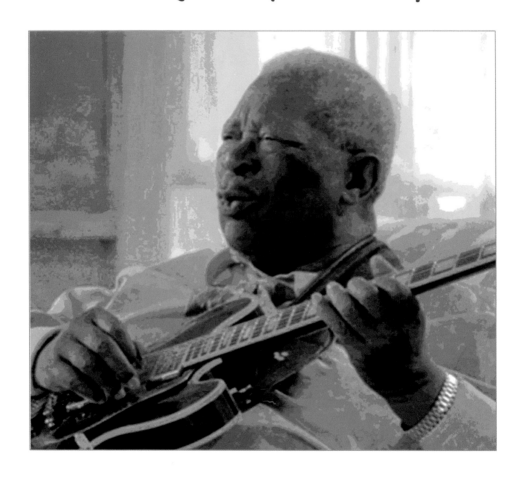

B.B. stops and thinks for a moment.
He looks down at his feet.

"Ha! THERE it is!"

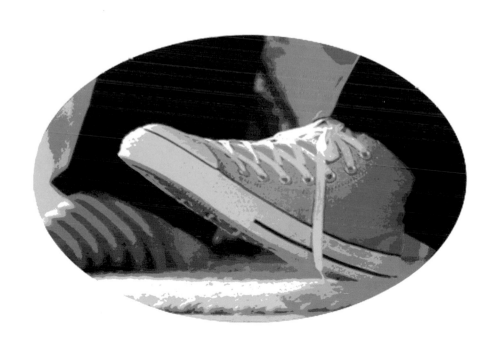

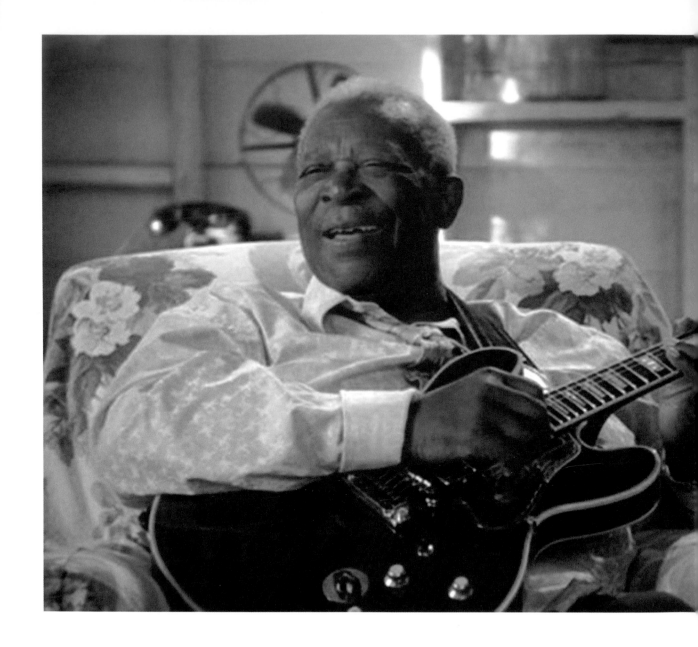

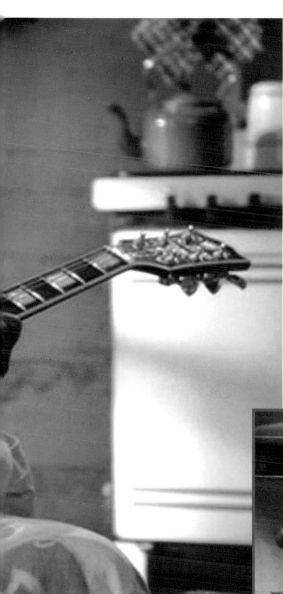

"I guess it was on my foot all along."

"Sheesh!"
whispers Dexter to Riley.

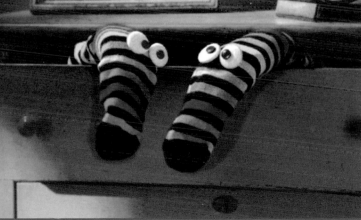

"Okay, I'm ready to go now!"
says B.B. cheerfully,
as Chaz and Argyle finish the song
with a spiffy riff on the piano.

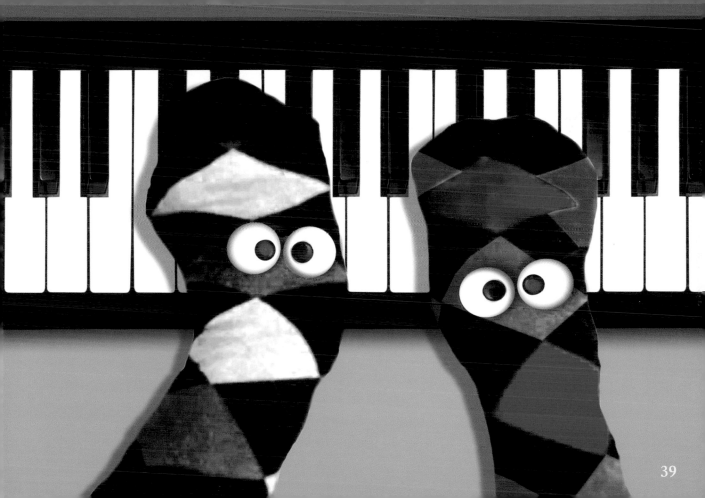

So that's that.
B.B. puts on his right shoe, and ties the laces.

Momsock is absolutely ready to go.
She picks up her pocketbook and heads for the door.

But there's one more thing…

"Anybody seen my coat?"

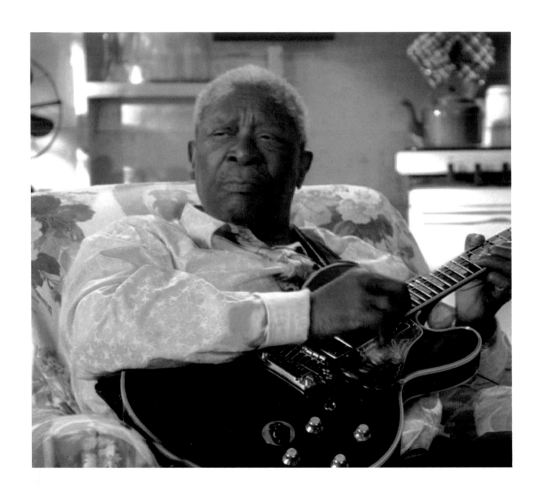

THE END

Now it's time to

MEET THE CAST →

MEET THE CAST

★ *The Stars* ★

B.B. KING

Most everyone calls him
The King of the Blues.
Though his old friends
just call him
"B."

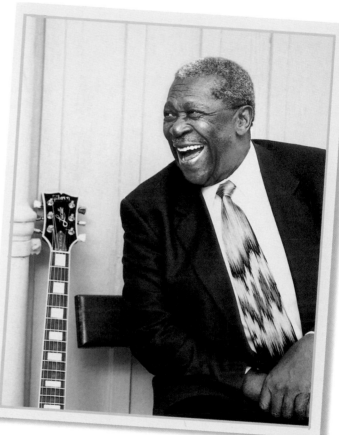

Lucille (B.B.'s guitar)

Feisty and clever and often unpredictable.
B.B. never goes anywhere without her.

Momsock

Renowned and admired as an actress, and also as a
truly stunning jazz saxophonist.

★ *The Supporting Players* ★

Many, many socks had to be sorted through before the
right ones were found for the smaller roles
in the *One Shoe Blues* movie. Here is a closer look
at this lively and close-knit group of actors.

Dexter and Riley

(The way you can tell it's not **Riley and Dexter** is that
Dexter's eyes are sapphire blue, and Riley's eyes are midnight black.)

Excitable and affectionate twins.

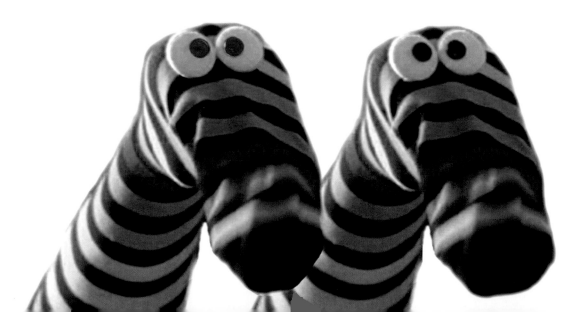

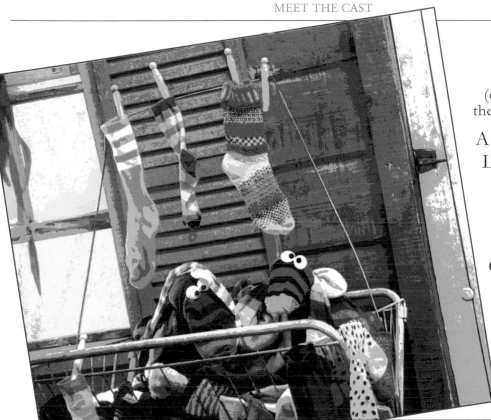

Scooter

(on the left, with
the sock on his head)

A very nice guy.
Loves to read.

Flash

Outgoing and funny.
Kind of loud.

Tippy

An excellent listener,
and a happy camper.

47

Argyle and Chaz

Terrific musicians, known for their zesty piano duets.
Argyle loves to golf on the Oregon coast.
Chaz prefers hiking in the Adirondacks.

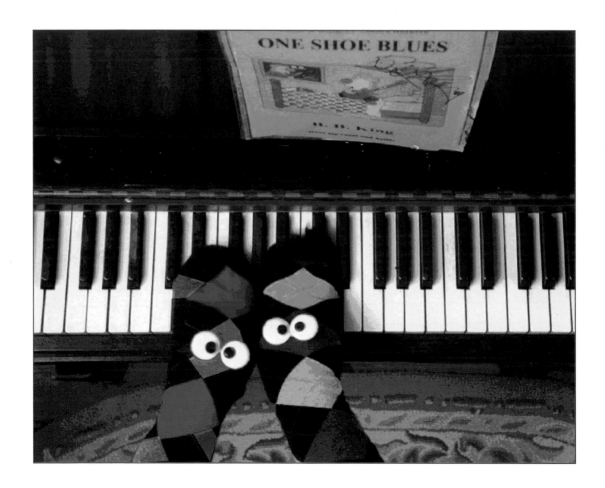

Okay, now YOU sing it!

THE SHEET MUSIC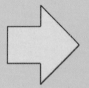

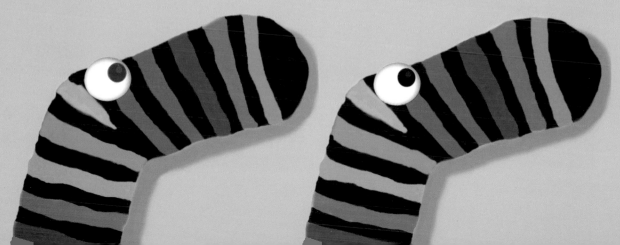

ONE SHOE BLUES

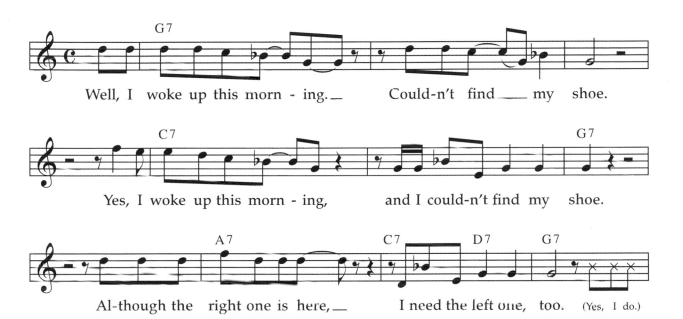

Well, I woke up this morn - ing. __ Could-n't find __ my shoe.

Yes, I woke up this morn - ing, and I could-n't find my shoe.

Al-though the right one is here, __ I need the left one, too. (Yes, I do.)

51

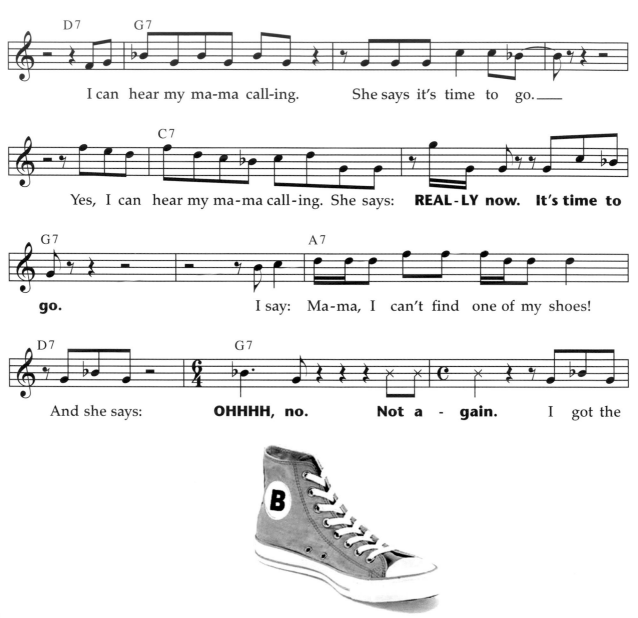

I can hear my ma-ma call-ing. She says it's time to go.____

Yes, I can hear my ma-ma call-ing. She says: **REAL-LY now. It's time to**

go. I say: Ma-ma, I can't find one of my shoes!

And she says: **OHHHH, no. Not a - gain.** I got the

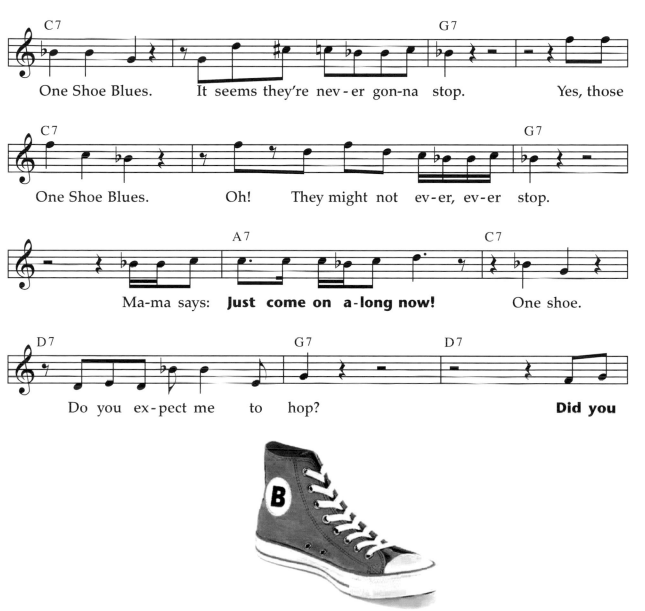

C7

One Shoe Blues. It seems they're nev-er gon-na stop. Yes, those

C7 G7

One Shoe Blues. Oh! They might not ev-er, ev-er stop.

A7 C7

Ma-ma says: **Just come on a-long now!** One shoe.

D7 G7 D7

Do you ex-pect me to hop? **Did you**

53

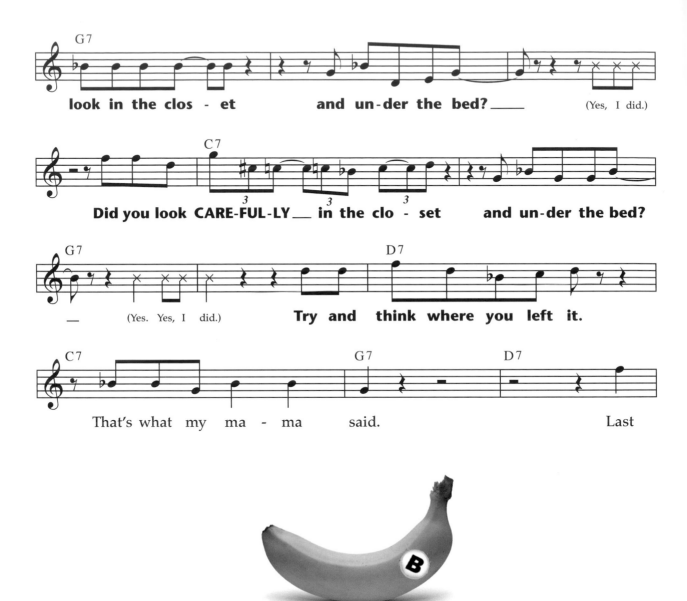

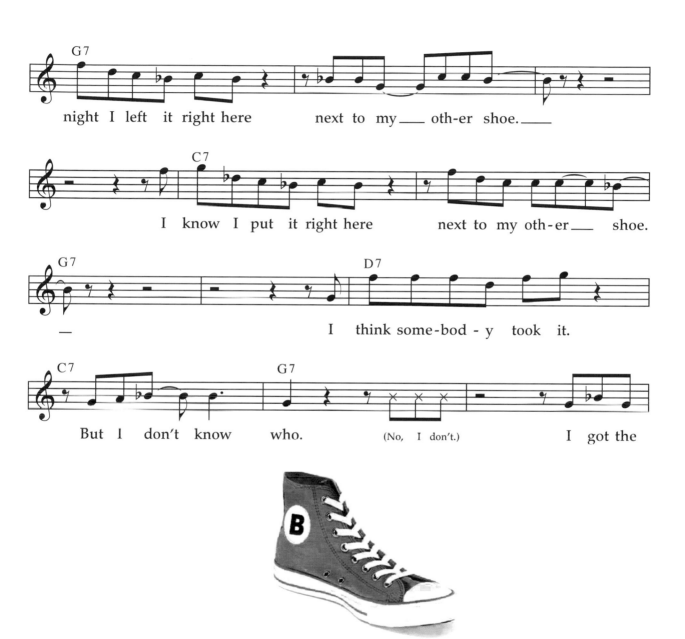

night I left it right here next to my ___ oth-er shoe. ___

I know I put it right here next to my oth-er ___ shoe.

— I think some-bod - y took it.

But I don't know who. (No, I don't.) I got the

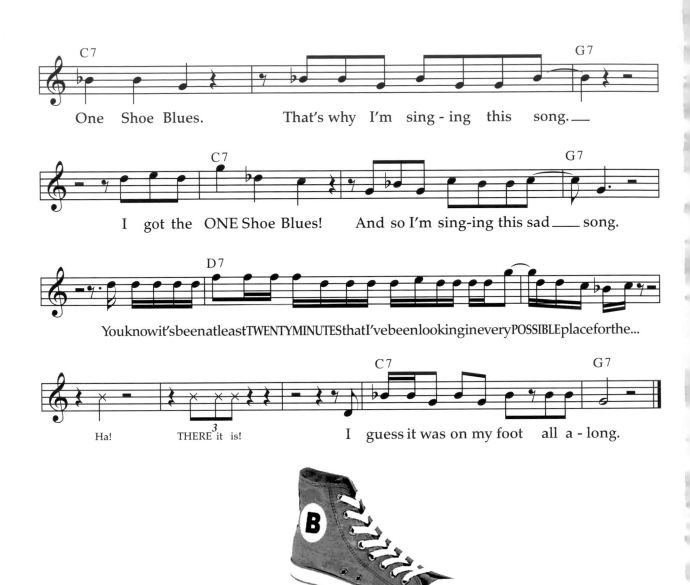

One Shoe Blues. That's why I'm sing-ing this song.

I got the ONE Shoe Blues! And so I'm sing-ing this sad song.

Youknowit'sbeenatleastTWENTYMINUTESthatI'vebeenlookingineveryPOSSIBLEplaceforthe...

Ha! THERE it is! I guess it was on my foot all a-long.

Goodbye! Happy trails!

MOVIE PRODUCTION CREDITS

Starring B.B. KING with MOMSOCK

Radio Voice BRUCE MORROW a.k.a. COUSIN BRUCIE

★

Produced, Written, and Directed by
SANDRA BOYNTON

★

Co-Produced by
MICHAEL FORD
RUSS KENDALL & MICAH MERRILL
KALEIDOSCOPE PICTURES

Director of Photography
BRIAN WILCOX

★

Documentary Videography
BETH ANDRIEN

★

Edited and Mixed by SANDRA BOYNTON & MICHAEL FORD

MOVIES

A LARGELY FICTITIOUS ENTITY

1ST AD Marc Vance
UNIT PRODUCTION MANAGER Russ Kendall
PRODUCTION DESIGN Sandra Boynton
POST-PRODUCTION SUPERVISOR Micah Merrill

CAMERAS
Brian Wilcox
Brian Sullivan
Dobber Price
Jason Painter

LIGHTING
Dave Stoddard

PUPPETEERS
James Creque
Sandra Boynton
Michael Ford

SOUND
Chris Tergesen
Michael Ford

ART & DESIGN
Steve Lee
Chad Davis
Matt Harris
Merry Jane Lee
Diana Eden

SET CONSTRUCTION
Scenic Solutions
Lynn Clark
Denton Mackenzie

POSITIVE VIBE TECHNICIAN
James Creque

WILDERNESS GUIDE Jef Huey

Filmed at Dreamvision Studios, Las Vegas, Nevada and on location in Northwestern Connecticut
Soundtrack mastered by Chris Gehringer, Sterling Sound, NYC
"One Shoe Blues" was originally recorded at Avatar Studios, NYC, and was first released on
BLUE MOO: 17 Jukebox Hits from Way Back Never
The wonderful B.B. KING is managed by the wonderful Tina France of B.B. KING ROADSHOWS LLC

YET ANOTHER CURIOUS BOYNTON/FORD PRODUCTION